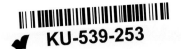

AKUBRA
IS AUSTRALIAN FOR HAT

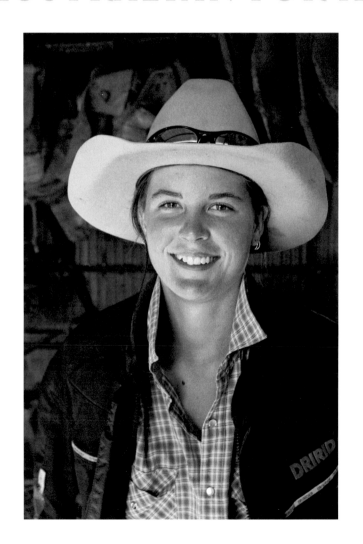

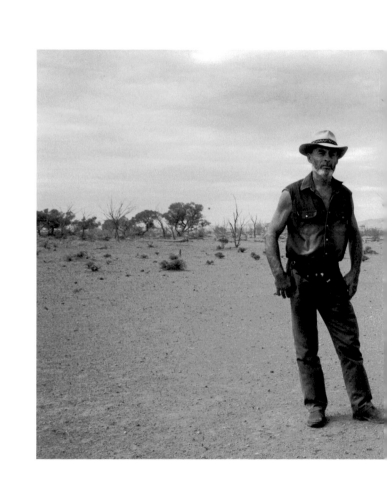

AKUBRA
IS AUSTRALIAN FOR HAT

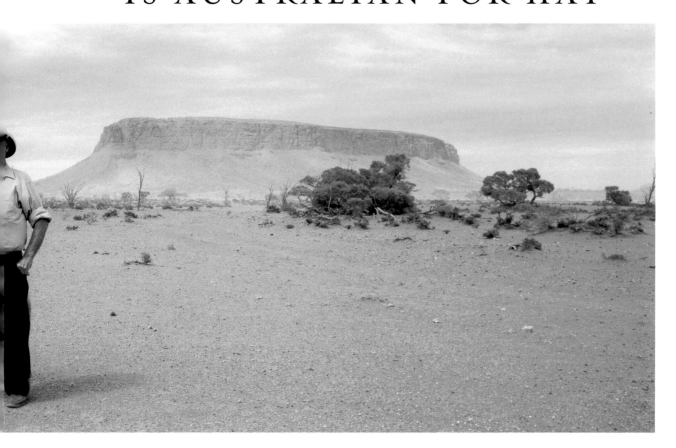

GRENVILLE TURNER

**Andrews McMeel
Publishing, LLC**
Kansas City • Sydney • London

ISBN-13: 978-0-7407-8505-4
ISBN-10: 0-7407-8505-2

09 10 11 12 13 WKT 10 9 8 7 6 5 4 3 2 1

www.andrewsmcmeel.com

ATTENTION: SCHOOLS AND BUSINESSES
Andrews McMeel books are available at quantity discounts with bulk purchase for educational, business, or sales promotional use. For information, please write to: Special Sales Department, Andrews McMeel Publishing—Australia Pty Limited, Level 1, 3 Brady Street, Mosman, NSW 2088, Australia.

Half title page: Kimberely Lane, a jillaroo on *Anna Creek Station*, South Australia, wears her hat to shade her from the sun.

Title page: Father and son, Ashley and Peter Severin, stand in front of *Curtin Springs Station's* finest feature: Mt. Conner, a 700-million-year-old mesa that lies about 100 kilometres east of Uluru in the southwest of the Northern Territory. The dust storm that swirls behind the two cattlemen and the stark red dirt with not a hint of green demonstrate the hardships endured by the pastoralists of the Red Centre.

KEITH RASHEED
Wilpena Pound Resort, South Australia

The former owner of Wilpena Pound Resort is renowned for his fascination with the colour pink and all things outback. He says it is his mum's influence from 60-odd years ago that makes him wear a hat. 'She used to say you wear a hat to keep your brains inside your head and not to fry 'em'. Keith wears an Akubra R.M. A keen horseman, he is known around Australia for the cattle drives he used to organise. 'When I was running cattle drives one of the stockmen saw a brown hat go up, then he saw a backside go up and then a cloud of dust'. And, as they say, once the hat goes, the rider goes too.

For Luke Fay-Turner

CONTENTS

FOREWORD

We must continue the fight against cancer because it is a First World disease about which we still have a lot to learn.

I rather value the fact that if I temporarily take off my hat of thinking about antibodies, immunological tolerance and the immune system in relation to cancer, I can put on another hat and say, 'Put on your hat and protect yourself from skin damage from the sun'.

A broad-brimmed hat provides excellent sun protection for the face, head, neck and ears. By encouraging family members, friends and work colleagues to wear a hat, we can all work together to ensure the welfare of our community.

Professor Emeritus Sir Gustav Nossal, AC CBE,
Australian of the Year 2000,
Patron of the Cancer Council of Australia

x

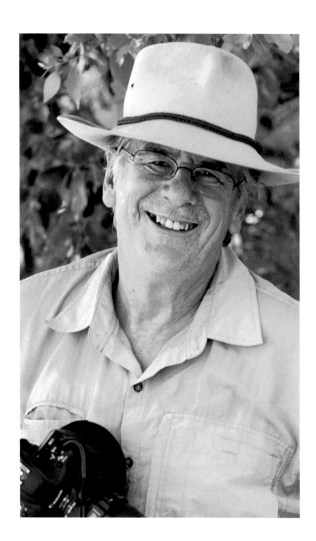

Grenville Turner, on location during the shoot
for *Akubra Is Australian for Hat.* (Photographed by
Grant Hunt)

INTRODUCTION

In 1984 I started seriously photographing people who wore the Akubra hat. After I had spent three years on the road and some more time in Sydney working on the project, the first edition of *Akubra Is Australian for Hat* was published in 1988.

For many years I considered remaking my hat book, and in 2008 I set forth around Australia looking for new hats and new stories. Over the years I've travelled many thousands of kilometres throughout Australia, and I have a network of friends and acquaintances, which in some ways made this new journey somewhat easier.

I followed a very similar route to the first journey, starting off at the Akubra hat factory in New South Wales and heading through western and northern New South Wales, up into Queensland, across the top to Darwin and down through the Northern Territory to the Red Centre into South Australia and Victoria.

I met some of the local legends of the outback—people like Bill King, who was the first tour guide to take tourists into the outback; R. M. Williams, who started off as Sidney Kidman's saddler; Peter Severin, who built the first landing strip at Ayers Rock by hand in addition to developing his remote cattle station; and Ian Conway, a modern pioneer who created a thriving tourism operation alongside his cattle station.

I visited the biggest cattle properties, not just in Australia but worldwide. I met very special people who not only wore a hat but also had fascinating stories to tell. It was an honour to meet these people and share a slice of their life.

I currently wear an Akubra Cattleman hat that protects me from the sun and hard knocks when I'm walking through the bush. It also regularly acts as a lens shade for my camera and is often used to shelter it when it's raining.

Grenville Turner

HATS FOR THE MAN OF THE LAND

A bushman expects a lot from a hat. It must stand up under the punishment of sun, rain, wind and rugged use. It must be a 'water your dog, fan the fire' model. Akubras have been Australia's leading hat makers for over half a century, and their hats are made to take this kind of treatment and still retain that authentic stockman look right through their long life. You can be sure that whichever style of Akubra you buy, either for bush work or town wear, it will serve you well.

Advertisement in R. M. Williams catalogue, 1972

XIII

R. M. WILLIAMS

A true son of the bush, R. M. Williams was still competing in the Winton to Longreach endurance ride in Queensland well into his 70s. He began his business empire in 1932 when he sold a handmade pack saddle to legendary cattle king Sir Sidney Kidman for five pounds. He is seen here wearing his Stetson, made under licence by Akubra. R. M. never went without his hat.

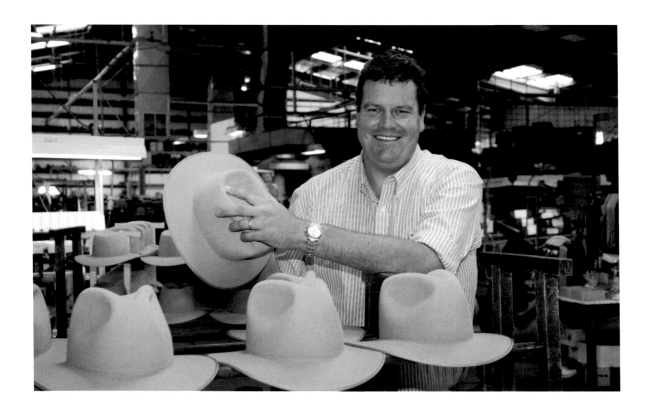

STEPHEN KEIR
Akubra Hat Factory

The fifth generation of the Keir family to take
the helm of Akubra at the headquarters in
Kempsey, New South Wales, Stephen Keir is
the managing director and wears a Traveller. 'It's
hard to know which one to wear when you have
so many, but I usually wear the Traveller. You
have to protect yourself from the sun—that's
what I'd say for hats in general'.

THE STORY OF THE AKUBRA

This book is about hats—Akubras—and the people who wear them. Behind every face under each hat is a representation of the landscape of Australia—the age, the mystery, the new, the old and most of all the colour and diversity of the people who together make Australia special.

The Akubra has nothing to do with class. For almost 100 years it has been worn by station hands, property owners, rouseabouts, railway fettlers, trappers and shooters, soldiers and, in the twenty-first century, by a legion of everyday Australians as a national insignia.

It was in August 1912 that the trade name 'Akubra', believed to be an Aboriginal word for 'head covering', came into use. However, the company's beginnings started earlier than that, in the 1870s, when a young engineer from Britain, Benjamin Dunkerley, established a small fur-cutting business in Tasmania. Ten years later, he moved his business to Sydney, where he opened a modest hat manufacturing plant in Surry Hills. There he met youthful hat maker Stephen Keir, who came from Manchester and whose expert workmanship impressed Benjamin. Stephen was soon manager of the hat-making business and became a son-in-law by marrying Benjamin's daughter, Ada. Since that

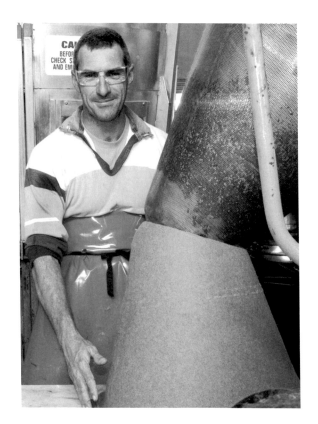

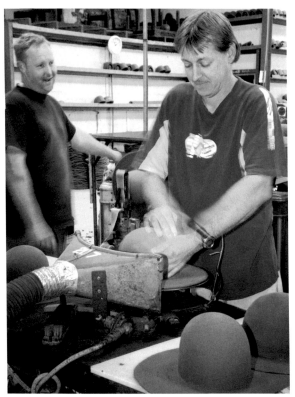

2

MICHAEL TERLICH
Akubra Hat Factory

Michael Terlich is forming the hat body. 'I am right at the start of the making of the hat. I wear an Akubra when I go fishing, when I mow the lawn, when I do most things. I have been here 20 years. It is like working with family'.

DARREN PEITSCH AND STANLEY DUCKETT
Akubra Hat Factory

Stanley Duckett (front) is 'taking the excess fur off the hat'. His colleague Darren Peitsch has his 'old army Akubra slouch hat as well as a couple of others at home'. Both men have clocked up two decades with Akubra.

time, the hat-making firm has been in the hands of succeeding generations of the Keir family. Today Stephen Keir IV is the managing director.

The Akubra has become Australia's national hat, with tens of millions of hats sold. Akubras have been worn by our slouch-hatted diggers in two world wars, presidents and prime ministers around the world have donned the famed hat, sportsmen and sportswomen wear Akubras, and 2008 Australian of the Year Lee Kernaghan never goes without the iconic Akubra. Once used by country people as a work hat, the Akubra is the hat of choice for Australians everywhere, whether you are in a suburban coffee shop, in a city boardroom, on a surf beach or chasing cattle in the Northern Territory.

The Akubra is made from the downy under-fur of the rabbit. The fur is put through a shearing machine to eliminate any long hair, and the under-fur is chemically treated to give it a shrinking capacity. Then the fur is blown to remove clots, hair and dirt, and when finished it looks like a piece of absorbent grey cotton.

Now the hat is coned in a forming machine. The fur for one hat is weighed out, deposited at the top of the cylinder and shucked down to settle on the revolving cone. Hot water is then sprayed to consolidate the fibres.

The felt is stripped from the cone; it is delicate and several times the height of the finished hat. The ensuing process is called shrinking and felting. Before the shrinkage is completed, the hats are dyed, and when the body-making process is completed, the hats are stretched and blocked. The finish comes by cutting down the fluffy appearance with fine sandpaper. Then the hat is steamed, pressed and ironed. After that, the finished product is trimmed with leather banding and lining.

At the end of it all, it is no ordinary piece of felt; it is an Akubra.

3

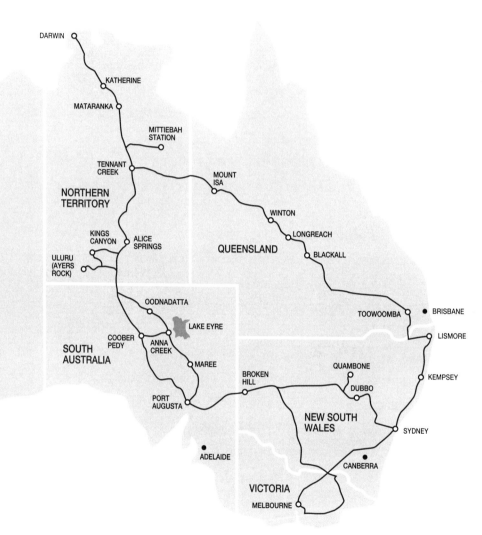

4

DARWIN

KATHERINE

MATARANKA

MITTIEBAH
STATION

TENNANT
CREEK

NORTHERN
TERRITORY

MOUNT
ISA

WINTON

LONGREACH

KINGS
CANYON

ALICE
SPRINGS

QUEENSLAND

ULURU
(AYERS
ROCK)

BLACKALL

WESTERN AUSTRALIA

OODNADATTA

LAKE EYRE

TOOWOOMBA

BRISBANE

COOBER
PEDY

ANNA
CREEK

LISMORE

SOUTH
AUSTRALIA

MAREE

QUAMBONE

KEMPSEY

PERTH

BROKEN
HILL

DUBBO

PORT
AUGUSTA

NEW SOUTH
WALES

SYDNEY

ADELAIDE

CANBERRA

VICTORIA

MELBOURNE

TASMANIA

HOBART

THE JOURNEY

Twenty years ago, I scoured Australia to photograph quintessential Aussie characters and their hats. In 2008 I ventured forth from Sydney to see if 'Akubra' was still Australian for 'hat', and it is. From the vast landscapes of the Top End through the iconic Red Centre to the cattle stations of South Australia and Queensland and beyond, we Aussies love our hats. And we wear them.

This new journey took me more than 10,000 kilometres across the country through extraordinary high temperatures, dust storms, electrical storms and floods. Not only did I see some of the best landscapes that Australia has to offer, but more important, I met some of our finest citizens.

It was a great opportunity to catch up with friends and acquaintances, new and old, and witness firsthand the lifestyles that reflect Australians and who we are. Whether you are a townie in northern New South Wales or a bushie in the sheep country of Victoria, your hat becomes synonymous with your story, and this is what I wanted to capture.

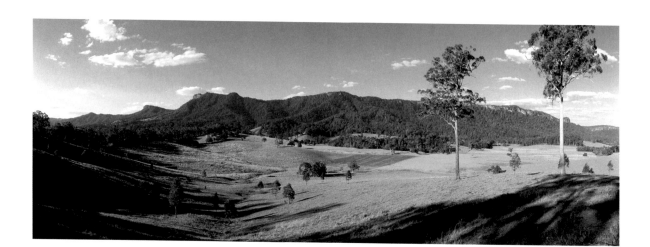

THE GREAT ESCARPMENT

The heritage-listed Lansdowne–Comboyne Escarpment is part of the Great Escarpment that runs east of the Great Divide almost the entire length of eastern Australia. The escarpment makes a significant contribution to the regional water catchment. Prominent volcanic plugs and exposed bedrock are characteristic of it. Once a busy farming community, the landscape now supports farmers, retirees and sea-changers.

TRAVELLING NORTH

It has often been said that the outback begins on the western side of the Great Divide. Most Australians live on the eastern side of this haphazard mountain range that starts in the tropical forests of Cape York and ends in the bluestone fortresses of the Grampians in southwestern Victoria.

The rich coastal fringe gives way to the rolling hills of the western plains, where the farm activities are as diverse as the character-driven locals who call this region home.

After I left Sydney, my journey took me along Highway One in a northward direction, sometimes tracking westward across the range but mostly toward north Queensland.

MIKE RICHARDSON
Lansdowne Escarpment, New South Wales

A reclusive natural historian eking out
a peripheral existence under the Great
Escarpment, Mike Richardson is often benighted
on his own property. He works part time as a
psychiatrist to the disadvantaged and would feel
naked west of the Great Divide without his hat,
and 'with a nose like mine you would do too'.

8

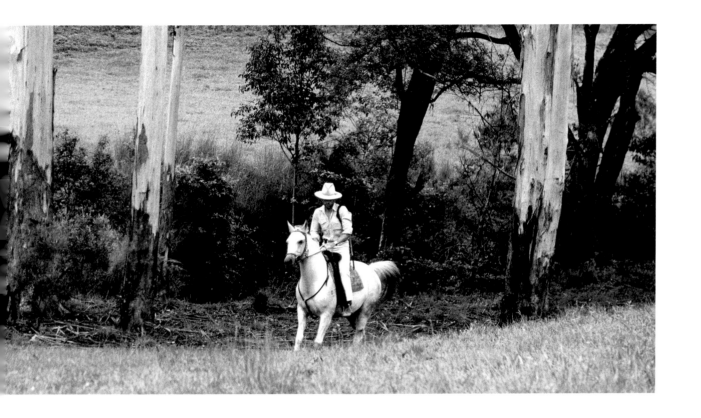

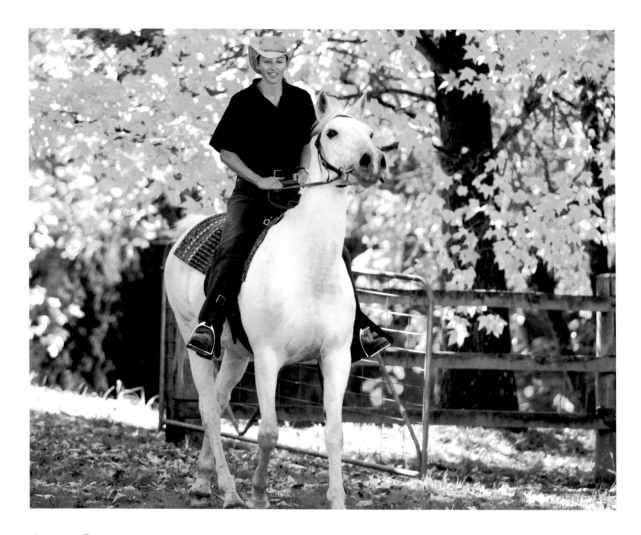

10

ANITA COOPER
Hookes Creek Forest Retreat, Barrington Tops,
New South Wales

Hookes Creek Forest Retreat rouseabout Anita
Cooper wears her Akubra every time she goes
riding.

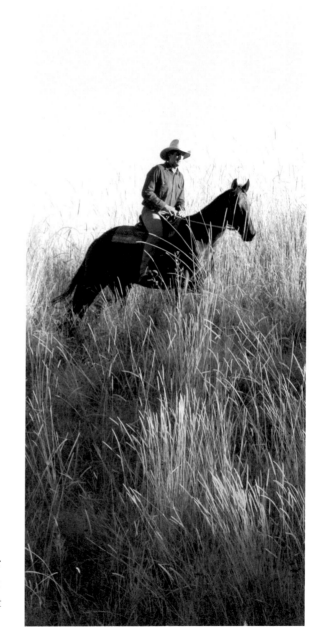

Jason Gizzi
Hookes Creek Forest Retreat, Barrington Tops,
New South Wales

'I like a well-worn hat, and well fitting so it
doesn't fly off my head when I am galloping after
cattle'. Jason Gizzi is a horseman and rouseabout
at Hookes Creek Forest Retreat. 'You shape a hat
to the way you like it, and you get attached to it'.

12

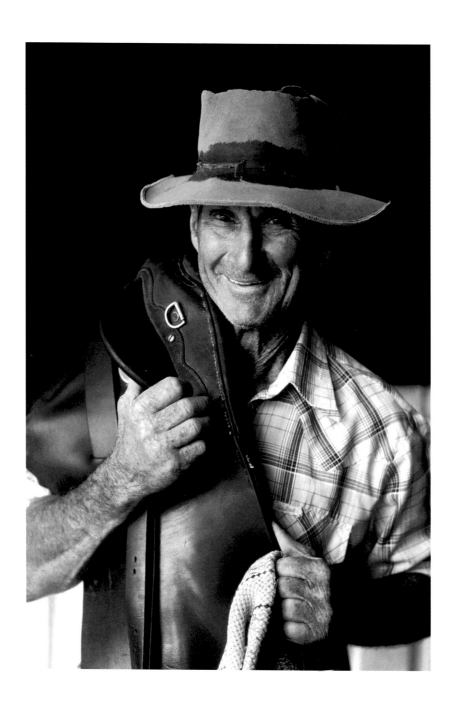

GEORGE WALTERS
Coraki, New South Wales

George Walters came from a property at Coraki. Famous among stock
horse breeders for winning draughts and prizes at rodeos, George was a
founding member of the Stock Horse Society. At 72 years of age he was still
wearing his Stetson because 'my parents always told me to wear a hat to stop
sunstroke. You can sum a fellow up by his hat'.

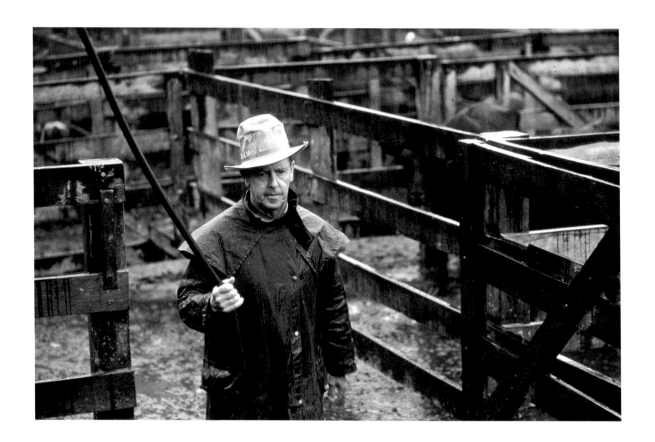

14

LISMORE SALEYARDS
Lismore, New South Wales

A hat can be used for many things—especially if
you're at the Lismore Saleyards and it's raining!

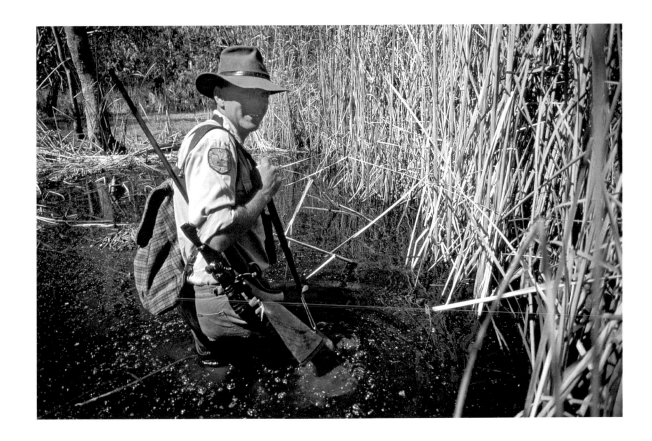

RAY JONES
Macquarie Marshes, New South Wales

A field officer with the Department of Environment and Climate Change at the Macquarie Marshes near Quambone, since 1991, Ray Jones has 'worn a hat all my working life. I even used to wear one to school. It's now part of my life. I wear it mainly for protection. I don't wear sunglasses, so it keeps the sun out of my eyes when I am looking for birds. It's a lot easier to use binoculars when you are not wearing sunglasses. My hat protects my head when going through the scrub, and it keeps the rain off as well. I used to keep a needle in the band so I could get burrs out of my hands and fingers'.

16

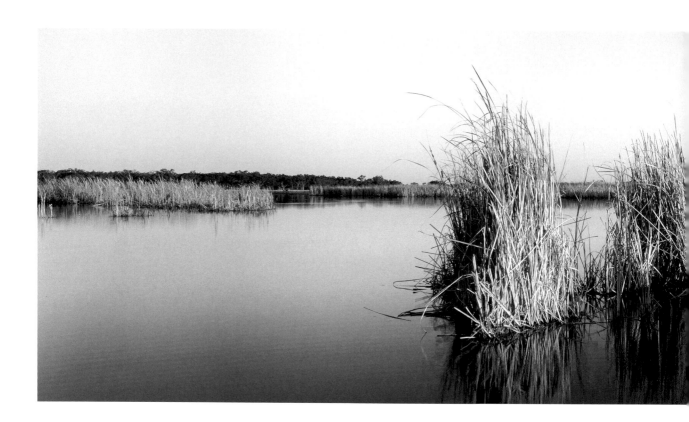

MACQUARIE MARSHES, NEW SOUTH WALES

A decade ago the Macquarie Marshes in western New South Wales was a thriving wetland supporting tens of thousands of migratory waterbirds. Early explorers were confounded by the vast, impassable marshes with their massive reed beds. Today this valuable wetland resource is all but gone, and it's men like Ray Jones and Eric Fisher who are the frontline warriors battling to save these endangered Ramsar wetlands.

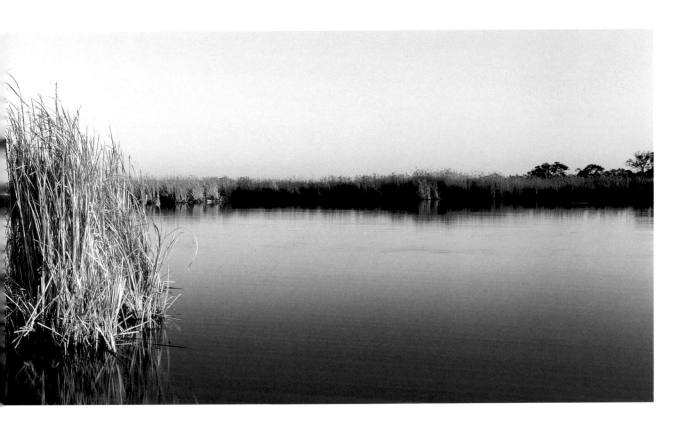

18

ERIC FISHER
Macquarie Marshes, New South Wales

Eric Fisher and his dog, Lloyd, live in the middle of the Macquarie Marshes
near Quambone, on the Wilgara Wetlands. His 15,000-hectare property has
been greatly affected by the lack of water and the decline of the marshes. His
Akubra Cattleman keeps the sun off his face. 'Wearing a hat has always been
a tradition; you've got to have a bit of shade'.

20

NICK GOODALL
Young, New South Wales

Photographed on his property *Coolibah* near
Young, Nick Goodall wears an Akubra Aussie
Gold hat because 'I feel naked without one.
Can't remember not wearing one. It's like
not wearing pants. Very definitely good for
protection and a useful tool—you can water the
horse, and it keeps the sun off your face'.

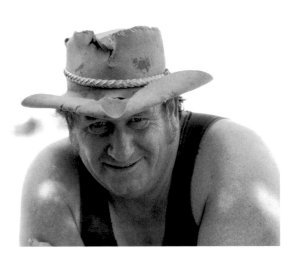

ROBERT DEWHURST
Nyngan, New South Wales

Robert Dewhurst is a professional kangaroo
shooter from Nyngan. He is wearing a very used
Silver Spur.

22

BROKEN HILL, NEW SOUTH WALES

This Mitchell grass plain near Broken Hill is
typical of the landscape in the far west of New
South Wales.

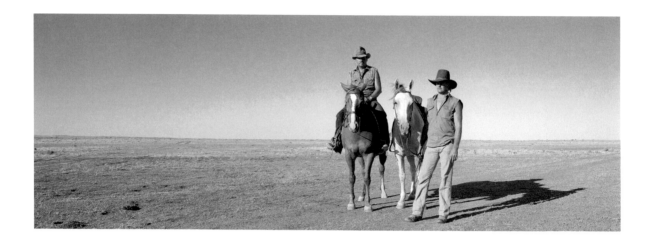

DOUG AND TONY ANDREWS
Broken Hill, New South Wales

Broken Hill grazier Doug Andrews wears an Akubra Cloncurry hat to 'keep the sun off'. Doug's son Tony (standing) was 18 when this picture was taken and a station hand on his father's property, *Farmcote Station*, stocked with 6000 head of sheep as well as cattle. Tony wears his hat for 'protection. There's been no rain for two years. I wear it because it feels comfortable and keeps my head warm. And you know the saying, bigger the hat the bigger the overdraft'.

JAMES MCCLURE
Western New South Wales

James McClure is pictured just before he headed out to go fencing on the 4450-hectare family sheep property, *Netallie Station*, 200 kilometres east of Broken Hill. James wears his Akubra for shade and to keep the flies off his face. 'It's a cultural thing'.

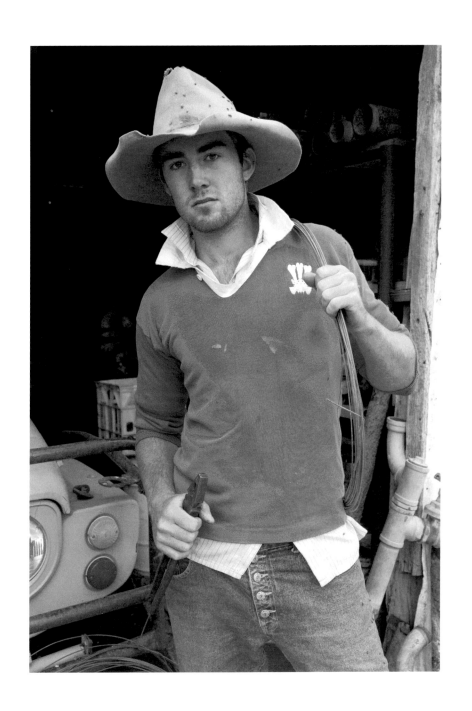

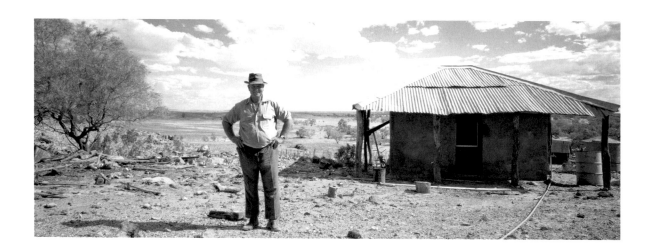

LYLE MORTON
Roseberth Station, Southern Queensland

Roseberth is a 4480 square kilometre remote cattle station located east of Birdsville in southern Queensland. Owner Lyle Morton stands in front of the old meat shed wearing his Akubra. 'You've gotta have a hat out here. There's no shade anywhere'.

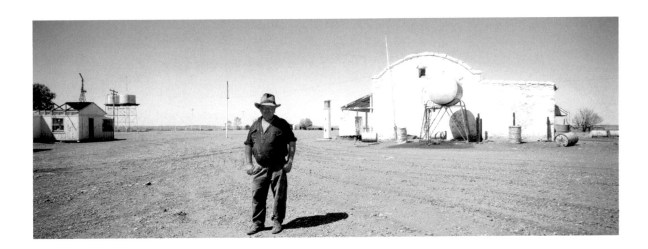

FRANK BOOTH
Cordillo Downs, South Australia

Frank Booth was the manager of *Cordillo Downs
Station*, a property of some 1553 square kilometres.
He would have been lost without his best friend:
an Akubra Sombrero. At one time, *Cordillo Downs*
was one of the largest properties in Australia,
running more than 80,000 head of sheep.

28

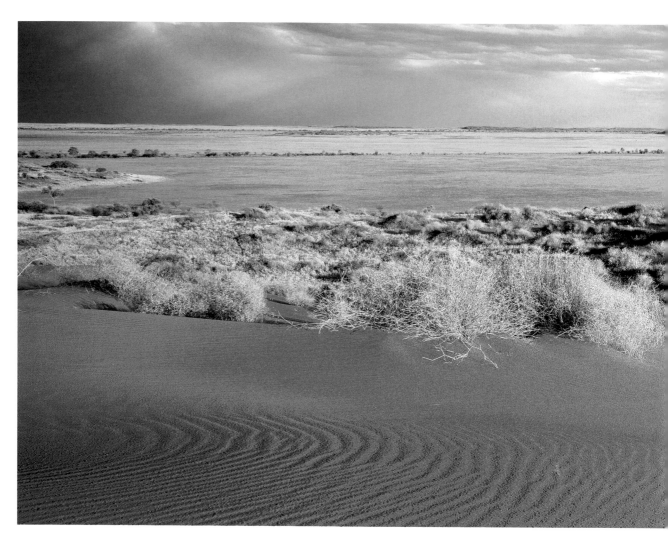

CORDILLO DOWNS
South Australia

Cordillo Downs lies in Sturt's Stony Desert southeast of Birdsville, Queensland, and north of Innamincka, South Australia. Here the beauty of the landscape belies the inhospitable nature of the land, where the flat, treeless gibber stone plain is broken only by occasional red sand dunes.

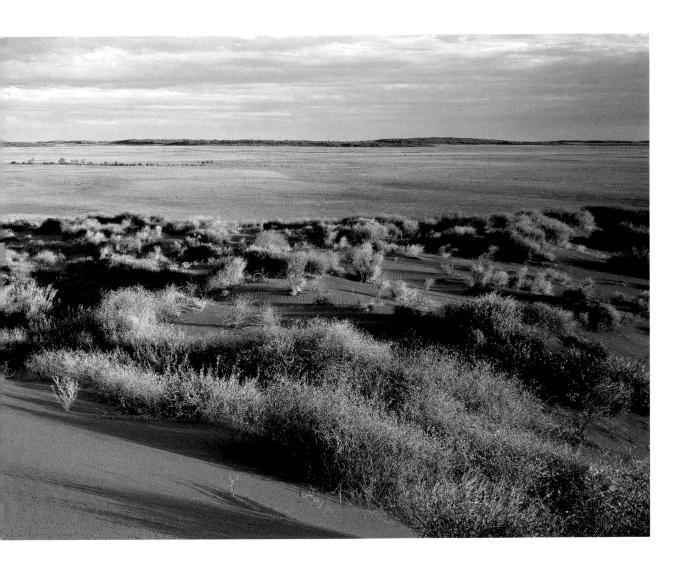

30

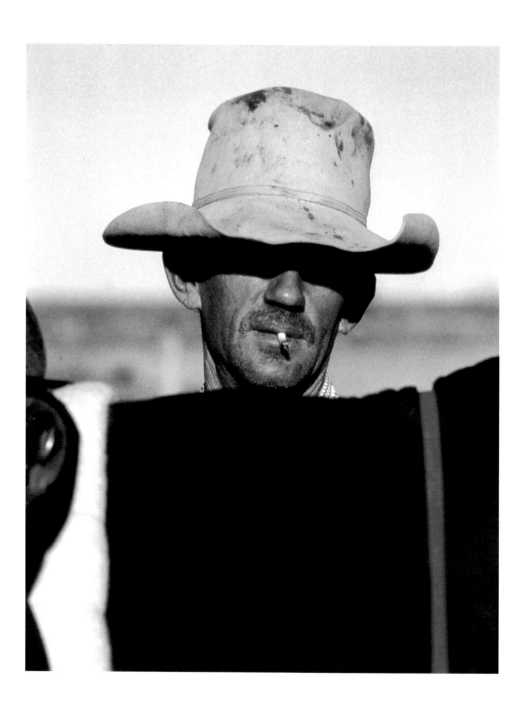

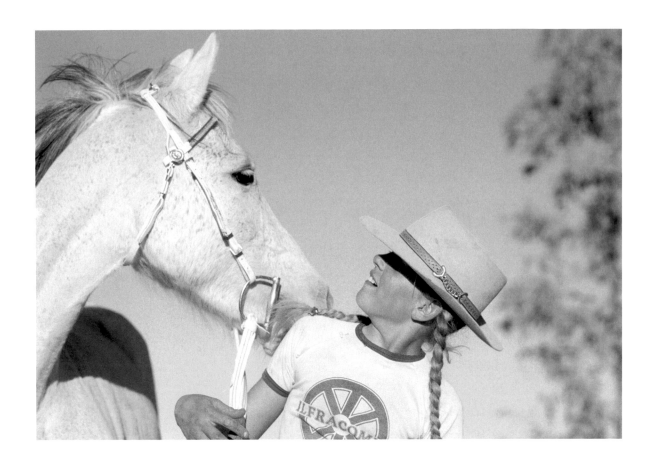

'BOY' FORSTER AND DESLEIGH FORSTER
Ilfrachrome, Queensland

'Boy' Forster comes from Ilfrachrome on the highway and railway line between Barcaldine and Longreach. A contract musterer and fencer, 'Boy' won the 230-kilometre Longreach to Winton endurance ride in 1984 with the help of his horse Ding. He looks menacing but is not, with his stained Bobby hat, cigarette and eyes shadowed by the brim—a true bush character. His daughter Desleigh wears her Dallas hat in the same way—a chip off the old block.

32

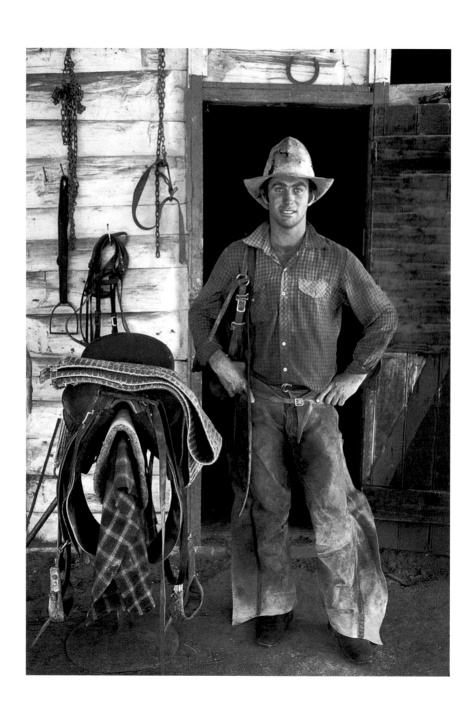

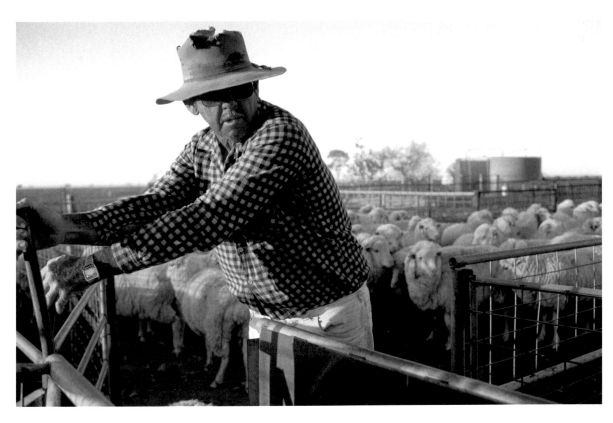

ROBBIE McINTOSH
Thomson River, Queensland

Photographed on his 1800-square-kilometre property *Fairfield* on the Thomson River near Longreach, Robbie McIntosh ran sheep, cattle and horses as well as Shetland ponies. He said he wore a hat because 'there's a lot of glare out here. It helps to shade my eye. You can't go out without a hat—don't feel dressed without it'. He wore a Boss of the Plains hat, which is most appropriate even though his crown was coming out.

GORDON ROBERTS
Babbaloora Station, Queensland

Gordon Roberts was a fourth-year jackaroo when this picture was taken at *Babbaloora Station* near Augathella, a settlement on the highway between Charleville and Blackall. He got dressed in his riding gear with all the tools of his trade just for this photograph.

34

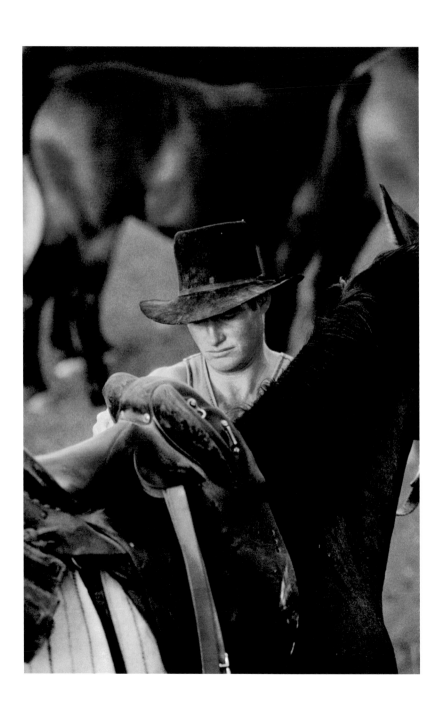

SADDLING UP, *RIVERSLEIGH STATION*
Gulf of Carpentaria, Queensland

A jackaroo saddling up on *Riversleigh Station* on the Gregory River before
the station was incorporated into the Lawn Hill National Park. The park is
renowned for the extensive vertebrate fossil deposits that are regarded as
some of the most significant in the world. Incredibly, a quarter of Australia's
known mammal species were recovered from *Riversleigh*. The park was listed
as a World Heritage Site in 1994.

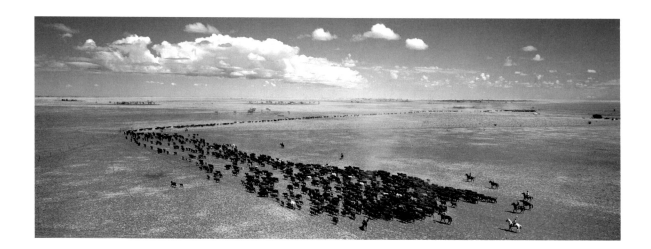

36

MITTIEBAH STATION
CATTLE MUSTER
Barkly Tablelands, Northern Territory

Stockmen push up a line of cattle toward a temporary yard on the Barkly Tablelands. Such roundups were an annual event on *Mittiebah Station* when this photograph was taken from the mustering helicopter. The three-week livestock muster takes on a carnival-like atmosphere as every member of the station staff joins in the activity.

ACROSS THE TOP

From Cape York in the east across the gulf country and the Barkly Tablelands through Arnhem Land, the Kimberley region through to Broome on the west coast is known as the Top End of Australia.

Here the landscape is vibrant and ever-changing, from lush tropical coastlines and savanna woodlands to extensive grasslands and open plains that seem to go on forever. The cattle stations are as large as small countries, and the people who live here are resourceful and entertaining.

My travels took me from northern Queensland to the border of the Northern Territory, from which I criss-crossed the north of the state, visiting locations east and west of the Stuart Highway, the lifeline that traverses the Territory from north to south.

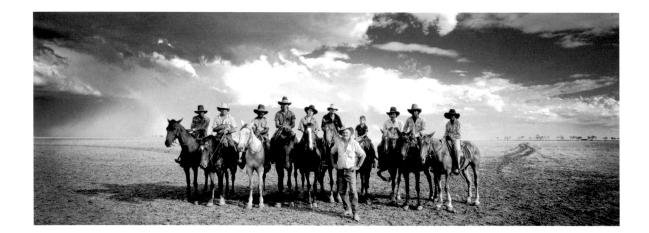

STOCKMEN ON *MITTIEBAH STATION*
Barkly Tablelands, Northern Territory

Mittiebah Station lies northwest of Camooweal
and is a 695,500-hectare property that carries
20,000 head of cattle, depending on the season.
Former owner Dave Joseland stands in front of
his stockmen and family members during the last
muster before the station was to be sold.

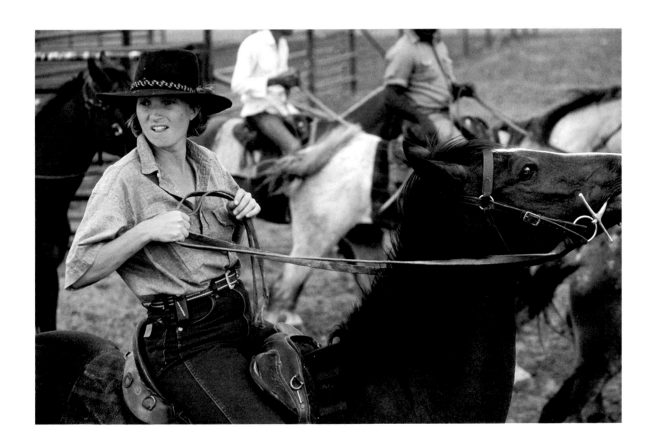

39

JANIE JOSELAND BENNETT
Mittiebah Station, Northern Territory

As a young horsewoman, Janie Joseland Bennett
helped with the final muster on the family's
Mittiebah Station. Today she is a renowned
documentary producer and photographer's agent
in the United States.

40

GEOFF JACKSON
Alexandria Station, Northern Territory

Geoff Jackson, the butcher at *Alexandria Station*,
lived in Lismore, New South Wales, and used
to spend six months at the station every year
during the dry season. He is seen here wearing a
Cloncurry hat; he has cut the brim off to make it
smaller since it was too wide.

TREVOR HAYNES

Alexandria Station, Northern Territory

At the time this picture was taken, Trevor Haynes was a second-year jackaroo at *Alexandria Station* and was wearing a quite new Akubra Bobby. He wore his hat to 'keep the sun off me, scare cattle and keep dust out of my eyes sometimes'.

TONY GRAHAM

Alexandria Station, Northern Territory

Another of the *Alexandria Station* jackaroos, Tony Graham has what is called the Kidman bash in his Akubra-made Stetson Top Rail hat. 'It takes a while to get a bit of character. If you're really wild, you kick it around the "flat"'.

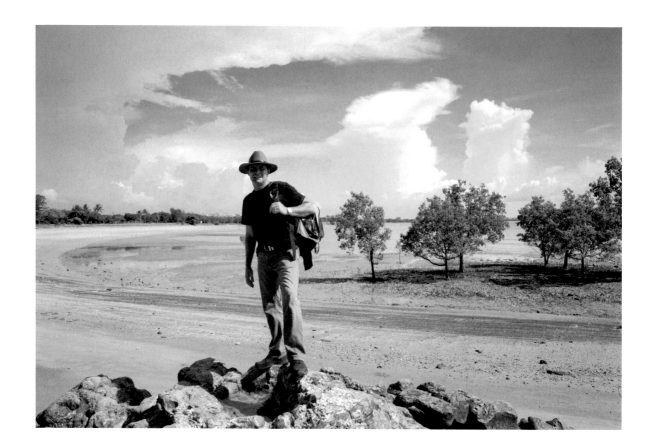

42

GRANT HUNT
Darwin, Northern Territory

'When I was growing up you always wore a hat—there were no bicycle helmets in those days. I like wearing a hat because I am from the bush. When I put on a hat I feel more like me'. Grant Hunt has been working in tourism for a long time. He has managed everything from large hotel complexes to small, intimate resorts, but his love is for his new venture into experiential tourism, Anthology. 'I found my niche in nature-based tourism. I feel more at home with nature and when I put on a hat I blend back into the landscape. I am very precious about my hat'.

43

STEPHEN TALBOT
Darwin, Northern Territory

John's brother Stephen is a carpenter by trade but 'will do anything' to make a dollar. He wanted to see Australia, so he 'headed off on my own last year—a year on the road. I had a Stockman hat before, but I left it on the dashboard, and it shrunk. The one I got in Alice Springs is a Rough Rider. I spent a bit of time putting a bash in it—needed to have shape. You have to make a hat look unique. Of course it's Akubra—that's Aussie, you know'.

JOHN TALBOT
Darwin, Northern Territory

Sydney elevator electrician John Talbot has left the bright lights and headed to the Northern Territory to 'travel around Australia and check it out'. He grew up on the western plains, 'so I wear an Akubra Western Plains hat. They don't make them any more, so no other bastard has one. It's nice and big and keeps the hair out of my eyes. It's my first hat'.

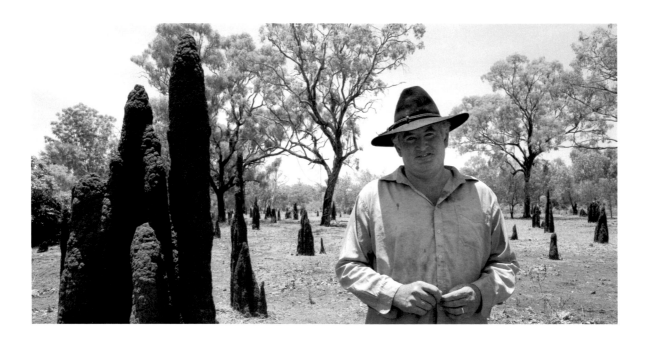

HAMISH MACFARLANE
Mataranka, Northern Territory

Hamish MacFarlane's family has a long history in Mataranka. This town is home to thermal springs, cattle stations and the setting for Jeannie Gunn's autobiographical book *We of the Never Never*. 'I wear a Bronco. It's a verandah to view the environment from under; otherwise you have to squint your eyes and you don't see enough. I worked out the best trick is to wriggle your head when you are holding a bull by the tail, and the hat calms the bull'.

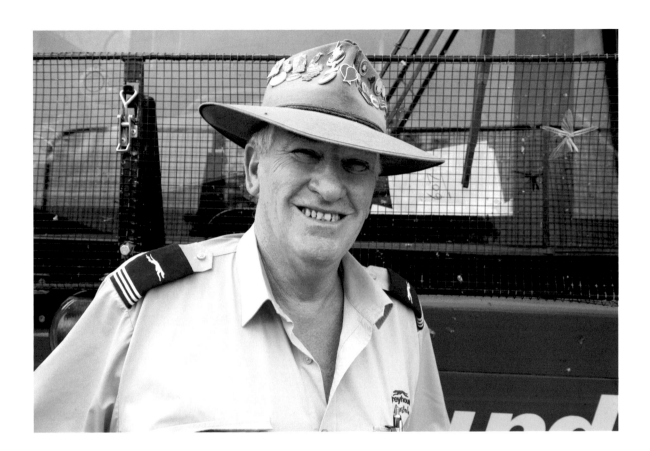

TERRY PERKINS
Dunmarra, Northern Territory

Terry Perkins has had his Akubra so long the name has worn away. 'Started driving buses in the mid-'80s and was doing the east coast for a while before me and the missus came to Darwin. You see a lot of the country. I wear a hat while I am driving to stop the glare'.

Terry drives the Darwin to Dunmarra run for Greyhound. 'I collect badges as we go. I have another hat at home—a Jackaroo—and it is full of badges and it is very heavy. The number of badges has grown a bit. Guess I will have to get another Akubra soon'.

46

CHAMBERS PILLAR
The Red Centre, Northern Territory

Located 160 kilometres south of Alice Springs, this sandstone formation rises 40 metres above the surrounding plain. Chambers Pillar was formed from sandstone deposited and worn down over 340 million years. Used as a guide by early explorers, it was named in 1860 by explorer John McDouall Stuart in honour of one of his expedition sponsors. Since then this spectacular solitary column has been visited by thousands of tourists and is at its most scenic at sunset.

THROUGH THE CENTRE

There is a reason why the Red Centre has its name: The ochre red earth glows under the searing hot sun. The sand is as fine as silk, and the continuous dunes are dotted with majestic desert oaks, scrubby mulga and unforgiving spinifex. Throughout this part of the Northern Territory, the inhabitants live by their wits, each one knowledgeable about the changeable nature of the environment and quietly confident that a new day will bring a new solution to the perils of the remote life.

From the hubbub of cosmopolitan Darwin, the 4WD nosed its way south through Mataranka, with its soothing thermal pools, to Tennant Creek and Alice Springs, where it is said that if you see the Todd River in flood three times, you are a local.

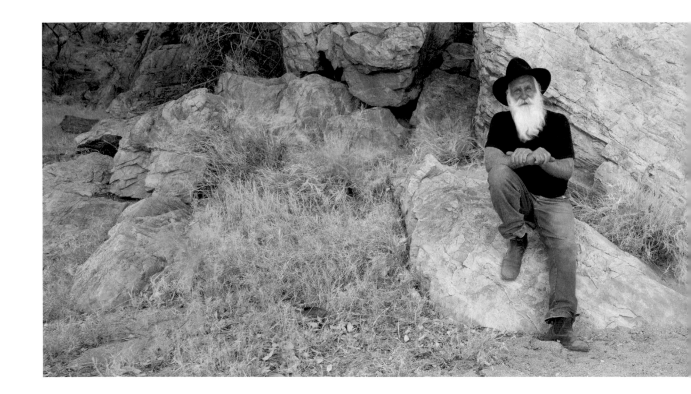

NOEL FULLERTON
Alice Springs, Northern Territory

The first Camel Cup run in Alice Springs was in 1970. It was a competition between two mates as an attraction for the centenary celebrations of the town. The concept was a hit, and one of the mates, Noel Fullerton, renowned Northern Territory cameleer, continued to supply camels for the race until the early 2000s. 'Two things always annoyed me in the summer: people who poured water over their head and people who would not wear hats. Your hat keeps your head cool. Always said the bigger the brim the better the hat. Not only that, but it stops your brain from riddling'. Noel wears an Akubra Bobby.

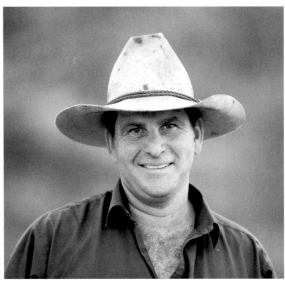

BEN HAYES
Alice Springs, Northern Territory

Undoolya Station is one of the oldest cattle stations in Central Australia and has been run by the Hayes family for five generations. The first Hayes came to The Alice in 1884, replacing the wooden telegraph poles with steel poles, and he stayed. Ben Hayes wears an Arena. 'I don't go anywhere without it. I have a clean one and a dirty one; this is the dirty one. I use it to swat flies. I use it to keep the sun off my head. I use it for everything; it's part of my uniform'.

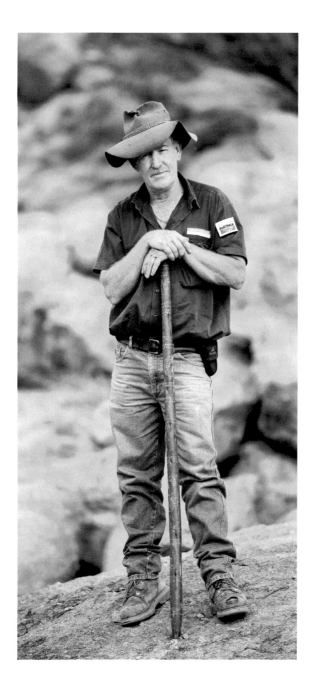

50

PHIL TAYLOR
Alice Springs, Northern Territory

Brought up on a sheep farm in South Australia, Phil Taylor moved to Alice Springs in 2003 as operations manager for Wayoutback Safaris. 'Why do I wear a hat? 'Cause I am a redhead and I have fair skin. This hat is a Territorian—a well-used Territorian. I have not had that many hats; I make them last. I use it for getting the fires going and swatting flies, and it comes in handy for dropping over the top of lizards'.

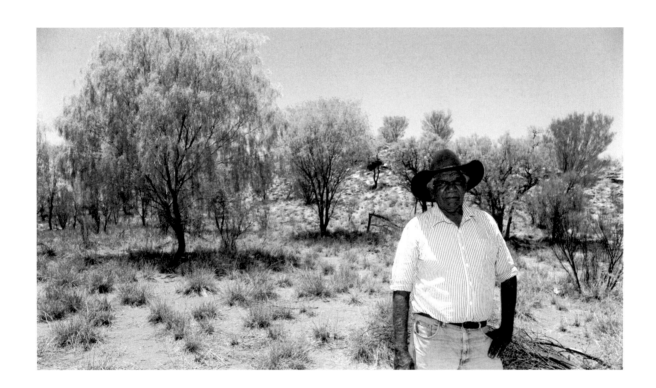

LINDSAY BOOKIE
Central Australia, Northern Territory

Aboriginal elder Lindsay Bookie runs an indigenous tourism business on his traditional homelands west of Alice Springs. 'I wear a Rough Rider. I normally wear my hat turned down in the front, but this is a new one and it takes a bit to get it into shape. My country goes right down to Lake Caroline and the Simpson Desert—400 kilometres. It is beautiful when the lake is full and the river is running. No one smart goes without a hat in this country'.

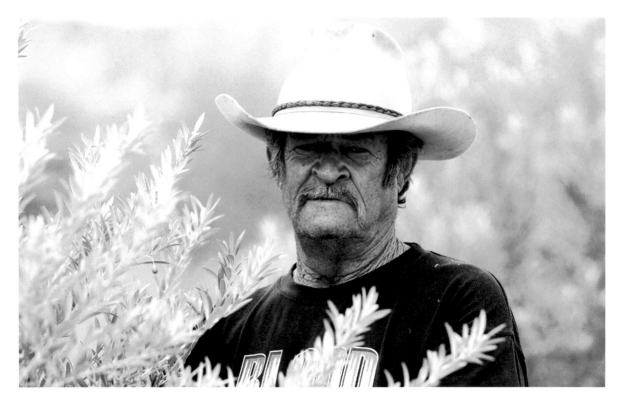

52

ROB LE ROSSIGNOL
Oak Valley, Northern Territory

Former jackaroo and horse breaker Rob Le Rossignol is the son-in-law of the traditional owner of Oak Valley, which is about 100 kilometres south of Alice Springs. He has planted the only commercial olive grove in the Northern Territory. 'It's not the hat, it's the man beneath it. I wear a hat out of habit. I grew up with it. Started wearing a hat full time when I was 12 years old at *Andado Station* in the Simpson Desert. Been wearing it ever since. Sometimes stoke up a fire with it, sometimes put it under my elbow if I want a nap under a tree, sometimes shade up a horse with it to show off, but mainly to keep the sun off my head. I have used the Sliver Spur since the mid-'50s 'til now. I never buy one in a box—off the shelf, on the head and home to shape it. Can't stand on the footpath shaping your hat—you look stupid. And you always take your hat off at the door'.

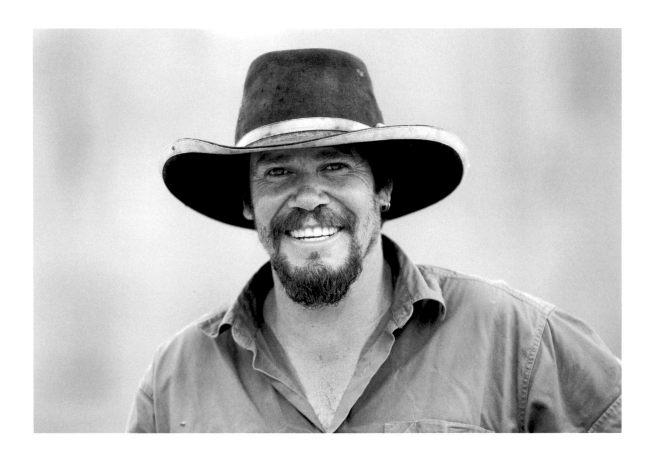

CRAIG ROSS
Oak Valley, Northern Territory

Son of Rob Le Rossignol, Craig Ross is passionate about the land on which he lives and works. When he is not guiding tours through his traditional homeland with his father or riding in rodeos, he breaks horses and paints traditional art works. 'I wear a Stetson. It is the only hat.

Been wearing 'em since 1983. A hat gives you stature. It's the lid. Hats have a purpose. My brother and I do a bit of rough riding, and you have to wear a hat for that. A hat tells what sort of guy you are. Guys who wear white hats are showoffs. Guys who wear black hats mean business'.

54

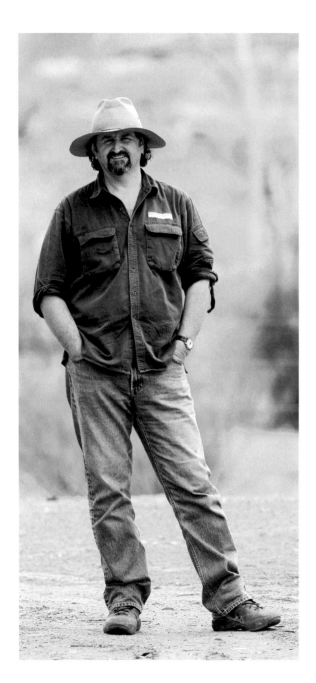

DON WAIT
Alice Springs, Northern Territory

Don Wait has been operating Wayoutback
Safaris in Alice Springs since 1999. He prides
himself on offering real outback experiences.
'My hat keeps me cool and keeps the sun out of
my eyes. On hot sunny days it comes out and
keeps the heat off my head and sun off my face.
If you say "hat" it has to be an Akubra'.

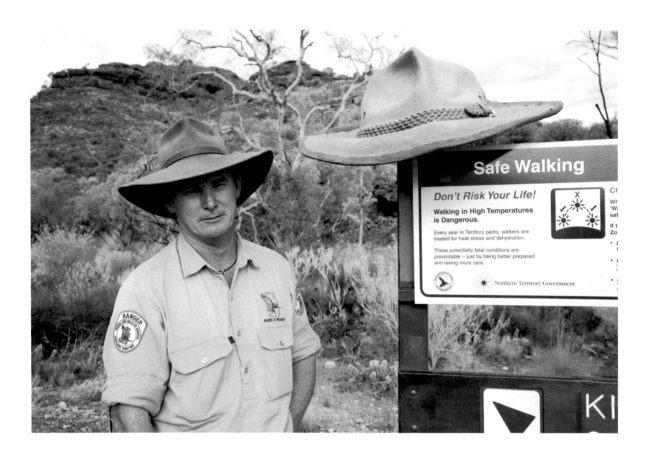

CHRIS HOWARD
Kings Canyon, Northern Territory

Chris Howard is the head ranger at Wattaka National Park, which incorporates Kings Canyon, between Alice Springs and Uluru in Central Australia. 'I have never been asked why I wear a hat. It might be God's country out here, but you have to take your shade with you. In the middle of summer you have to give the flies somewhere to hide. This is a Territorian. Has a good wide brim. I used to wear a Cattleman, but then I came across this one, and it's perfect for out here. If you are gonna have a hat, you have to have a good one'.

56

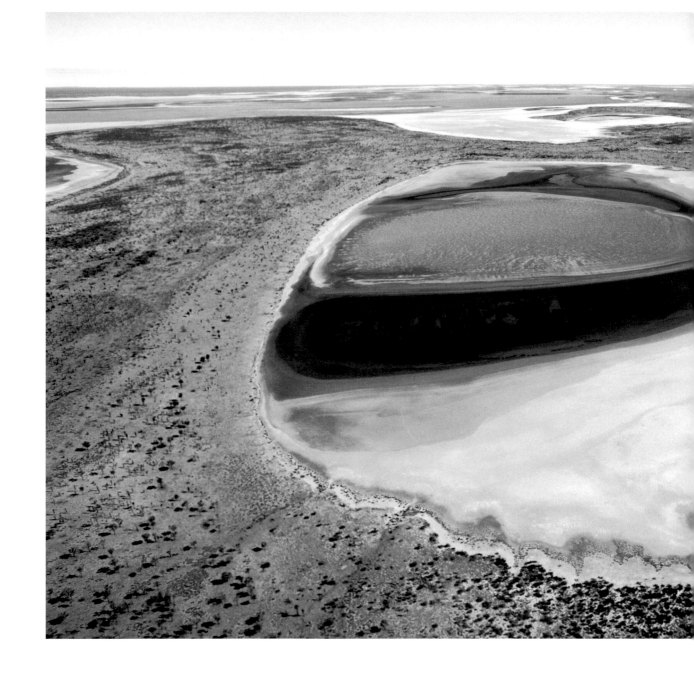

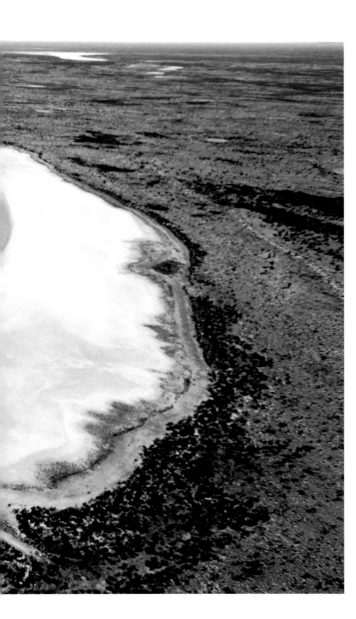

LAKE AMADEUS
Northern Territory

Lake Amadeus is the largest salt lake in the Northern Territory at 180 kilometres long and 10 kilometres wide. It contains 600 million tonnes of salt, but its remote location hinders viable harvesting. Both *Curtin Springs* and *Kings Creek Station* border this lake, which thwarted explorers for decades.

57

58

JAMES ORTON
Kings Creek Station, Northern Territory

City boy James Orton has worked at *Kings Creek Station* for half a year as a handyman and rouseabout. 'I wear a Golden Spur. It's a new one. I think I was one of the first to buy one. I used to have the Arena, but I like this one better because the Arena looked funny on me.

I need something for my ears to hold up. This is my fifth Akubra all up. Wearing this hat is truly Australian. If there is a possibility of my face being in a book about hats, I don't care if I miss my dinner'.

IAN CONWAY

Kings Creek Station, Northern Territory

Raised by his traditional Aboriginal grand-mother, Ian Conway spent his formative years on the back of a horse working with his stock-man father. He and his wife, Lyn, run *Kings Creek Station*, a successful tourist destination and cattle station. Ian wears a Snowy River. 'Been wearing a hat for 40 odd years. Hats have many uses: We use it for storing your wheel nuts, picking up hot things, getting over barbwire fences, drinking container, or for a plate for eating your steak. You can just take it off your head and use it. Mainly I use it to keep the sun off. I've suffered from skin cancer, and my Akubra is cooler than any other hat. I always have a good one and a work hat. Once you have worn a hat you can't go without it'.

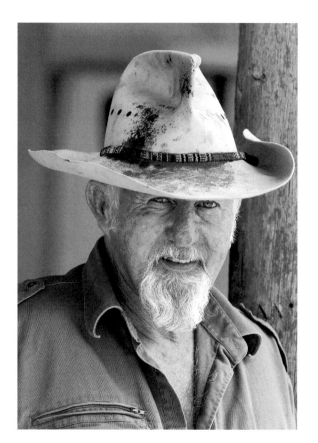

IAN 'UNCLE' PARKER
Curtin Springs Station, Northern Territory

Ian 'Uncle' Parker has worked at *Curtin Springs Station* in Central Australia for more than a decade. 'Uncle' wears a Bronco. 'Why the Bronco? 'Cause I couldn't get a Bobby and it's a bit lighter. First thing I do is to put a bash in it. Doesn't take long. If you have a hot billy, you can pick it up with the hat, and it's good for flogging the dog, or the missus. Is she listening? It keeps the flies off the top of me head, and it's good to keep the sun off, and you can always use it for a pannikin. Always worn a hat and always will. Never go out without one. This is my Sunday hat, working hat, everyday hat'.

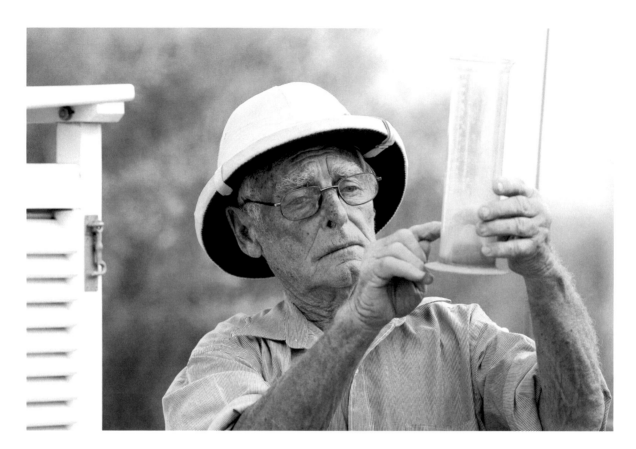

PETER SEVERIN

Curtin Springs Station, Northern Territory

Peter Severin is a bit of a legend in the Northern Territory. The owner and operator of the *Curtin Springs* cattle station and tourist roadhouse with his son, Ashley, Peter has seen more than his fair share of hard times. He has a quick wit and an even sharper tongue for the fools he refuses to tolerate. 'There hasn't been a decent drop of rain in seven years'. And he would know since he has been collecting weather information for the Bureau of Meteorology for more than 50 years. 'I wear an Akubra Bronco, but I can't find it. About 10 years ago I was in India with the wife and we were chatting to a policeman. He had a helmet on, and I said, "I want to buy your hat!" No money changed hands; he just said, "Yours". I must have been "pithed" when I got it'.

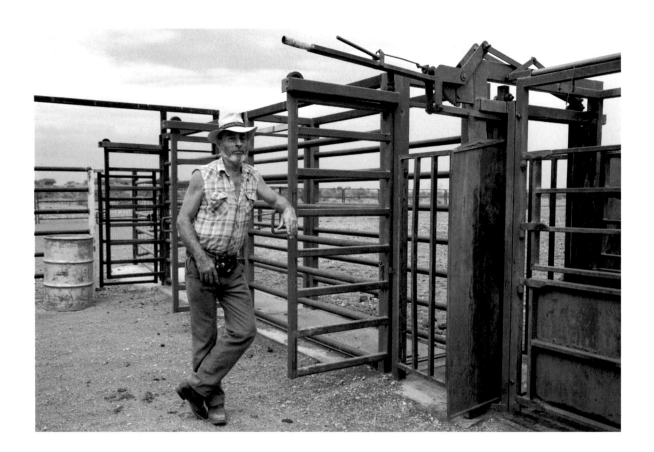

ASHLEY SEVERIN
Curtin Springs Station, Northern Territory

He came to *Curtin Springs* as a child in 1956 when his parents bought the station. Like his father, Peter, Ashley Severin has lived through good and bad times in this 4166-square-kilometre corner of the outback, but the last seven years of drought have been the toughest. 'Why do I like the cattle crush? Because it's green! I wear an Akubra Stockman. I was going to bring out my Sunday walking one, but I figure you wanted to see the working one. A cap doesn't shade your neck or your eyes. You feel naked without your hat'.

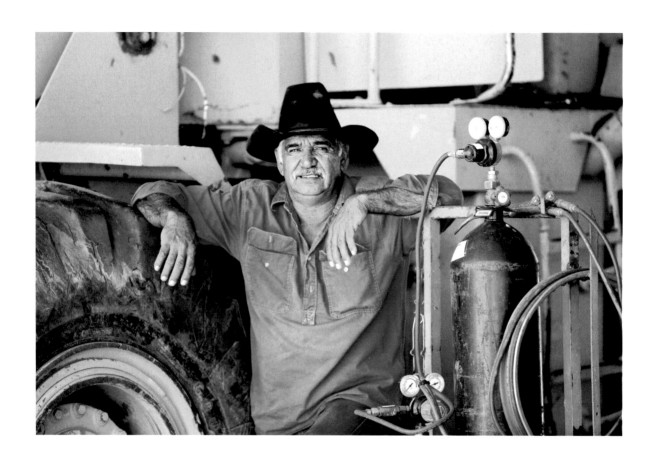

GORDON WARREN

Anna Creek Station, South Australia

Gordon Warren is the head stockman at *Anna Creek Station*. This is the largest cattle station in the world, and at 26,000 square kilometres, it is roughly the size of Belgium and four times the size of America's largest ranch. 'I wear a Woomera hat. I have lived at *Anna Creek* most of my life and have worn a hat all my life. When the temperature gets really high it protects your head. And it's a pretty good tool, especially if a cow or a bull chases you. You can always throw it, or you can water your horse or your dog with your hat. Have to remember you can judge a man by how he wears his hat. These days you gotta tell the younger ones to wear a hat'.

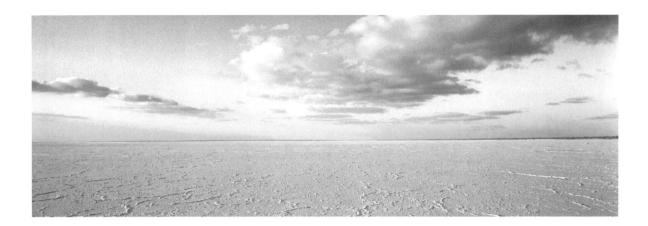

64

Lake Eyre
South Australia

Lake Eyre is the lowest point in Australia at approximately 15 metres below sea level. On the rare occasions that it fills, it is the largest lake in Australia. Located about 700 kilometres north of Adelaide, the massive salt lake is fed by runoff during the rainy season in the north. It can take up to six weeks for the water to reach the lake. Since 1885 the lake has filled only nine times, with a record six-metre depth in 1974.

SOUTH OF THE BORDER

Don't be fooled: The southern climes of Australia can be just as inhospitable and as surprising as locations further north. Frequently drought ridden, South Australia is renowned for its amazing landforms, like the geologically astounding Flinders Ranges, where the push and pull of the earth's surface has created a visual feast of colour and unwittingly established a photographer's paradise.

Everything is the biggest in this region: the largest salt lake in the world at Lake Eyre and, nearby, the largest cattle station on the planet, *Anna Creek Station*. Even the people seem larger than life, and they have to be to thrive in a place where seven long years of drought can be dispelled in an overnight dumping of rain that leaves the arid hillsides alive with green tips of life-saving grass and colourful swatches of wildflowers.

I travelled back and forth along the Oodnadatta Track, hundreds of kilometres of dirt track that threads its way to Maree, and then headed south and east through the Flinders Ranges and into the rolling farmland of western New South Wales and Victoria.

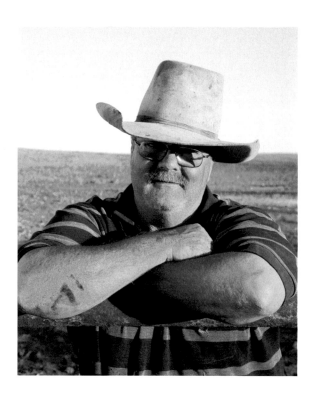

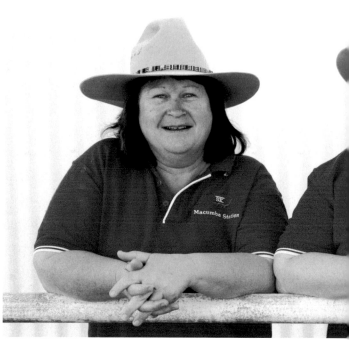

EDDIE NUNN

Macumba Station, South Australia

Eddie Nunn is the manager of *Macumba Station*, a 6500-square-kilometre S. Kidman & Co. cattle station off the Oodnadatta Track on the fringe of the Simpson Desert. 'Like everyone around here, I wear a Woomera. When it was all horses, we used to use it for water drinking. Seen someone put rum in it at a bachelor and spinster ball a while back. We always wear hats when drafting cattle. When Kidman puts young guys on, they have to wear a hat. It's a rule around here'.

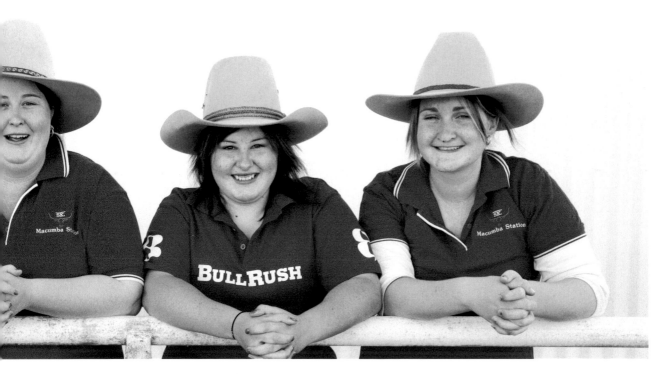

GERRY, HAYLEY AND CHLOE NUNN AND CHLOE JOHNSON
Macumba Station, South Australia

Lining up to show off their hats are (from left) Gerry Nunn, Hayley Nunn, Chloe Johnson and Chloe Nunn. Gerry, the wife of *Macumba Station* manager Eddie Nunn, wears a Bronco. 'It's a fashion item at gymkhanas and bronco branding. Anyway, you get too sunburnt without it out here'.

Hayley wears her Arena because 'it looks after my face', and the two Chloes are school chums who wear their Arena and Woomera Akubras when they visit from boarding school.

68

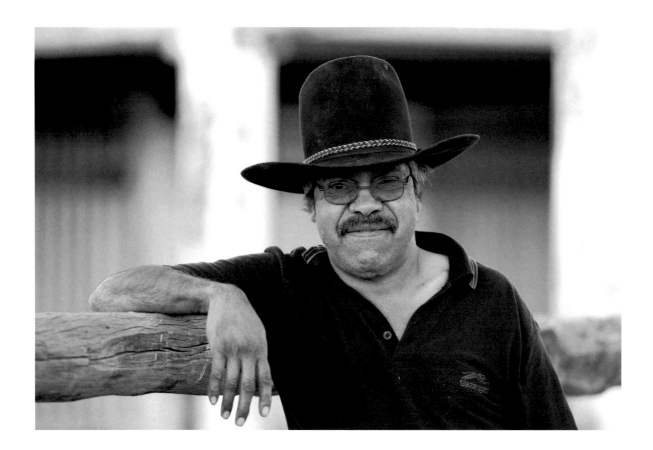

ARNOLD WARREN
Macumba Station, South Australia

One of the stockmen working on *Macumba Station*, Arnold Warren wears the Woomera 'for the shade. I always wear it, especially when I go to town and to the shows. It shows I am a stockman'.

GREGORY WARREN
Macumba Station, South Australia

Gregory Warren is also a stockman on *Macumba Station*, and he's Arnold's cousin. 'I wear my Akubra for the shade, I suppose. You wave it at the cattle when they play up. And I always wear it to town like Arnold'.

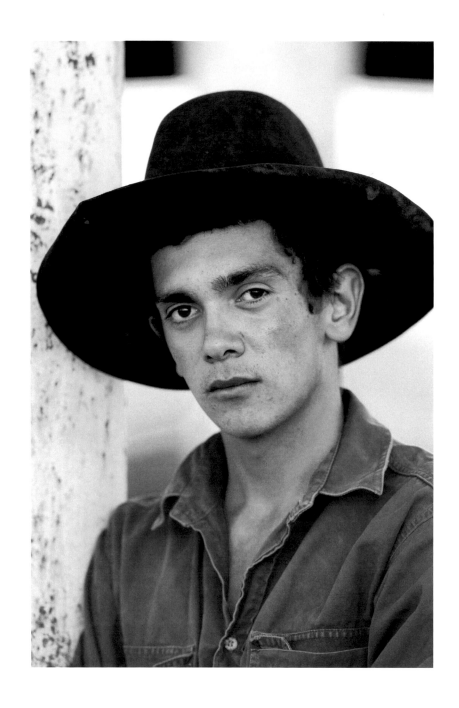

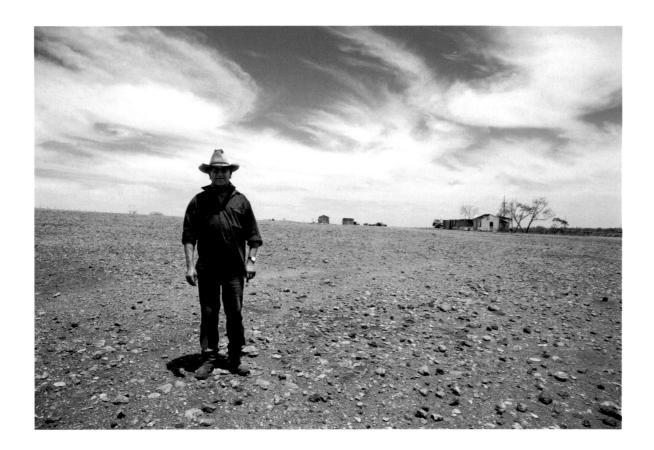

BOBBY HUNTER

Mabel Creek Station, South Australia

Bobby Hunter has been a stockman since he was 10 years old. He worked at *Anna Creek Station* for 19 years and now is at *Mabel Creek Station* near Coober Pedy. He claims he was one of the first people to wear an Akubra Woomera and credits the hat with saving his life. 'I was running away from a bull and jumped over a gate and got my arms caught. Fell down on my head. Broke my neck, but I think the hat saved me life. I am attached to this hat now 'cause it saved my life. Stopped my head from hitting the ground— softened the blow. I bet no one in the world has a story like that'.

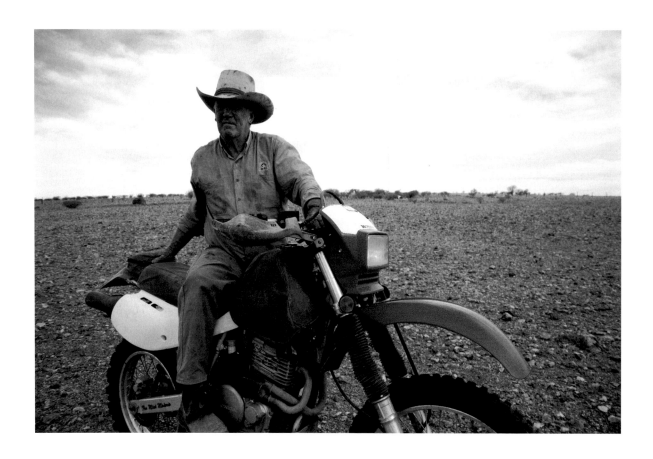

STUART NUNN
Mabel Creek Station, South Australia

Leaseholder of *Mabel Creek Station* near Coober Pedy, Stuart Nunn was raised on *Anna Creek Station* and until recently was the pastoral manager for S. Kidman & Co. Stuart is an easy-going cattleman who has a wealth of knowledge of the land. 'Always was taught you must wear a hat. You have to have that protection from the sun. Being fair skinned, I need it. The wider the brim, the better the hat, that's why I wear a Woomera. A lot of others don't have a big brim. Started off as me good hat—now it's me work hat—has to earn its day. Silly caps came in, and you see all these young fellas with burnt ears. Dumb—they'll end up with skin cancer'.

72

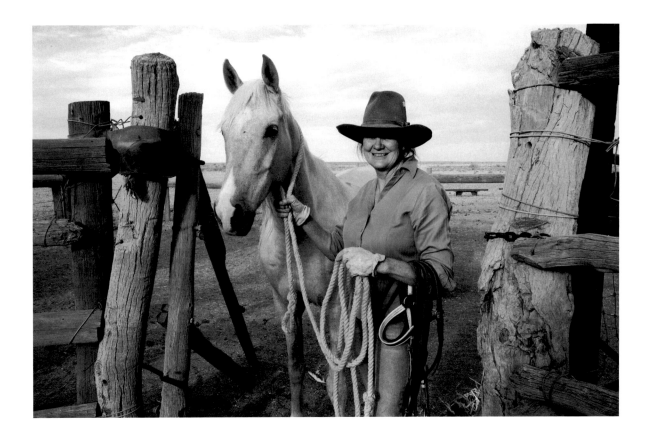

LYN LITCHFIELD
Wilpoorina Station, South Australia

Lyn has lived at *Wilpoorina Station* since she married Gordon Litchfield in the mid-1970s. She works as the local nurse and teaches horse riding. She has a grand passion to compete with one of her beloved Arabs in an endurance ride and is training for just that. '"Wilpoorina" means "out on the flat with little water". Been here since 1976 and haven't seen much water. You know, with this much sun, you need a lot of shade'.

'When my son Adam met his fiancée, Kate, he bought her a $300 Akubra hat. When they got engaged he bought her a ring from Coles. You know what sort of man you are getting when he buys you the best hat for this kind of country'.

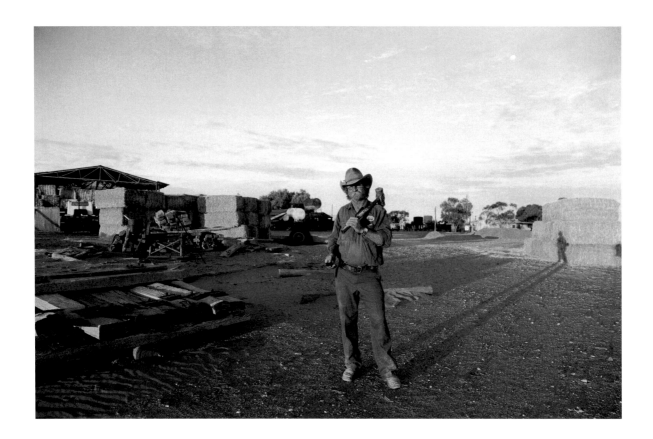

GORDON LITCHFIELD
Wilpoorina Station, South Australia

The Litchfields have been living in the Marree area of South Australia for generations. Gordon Litchfield and his wife, Lyn, own *Wilpoorina Station*, which is next door to *Mundowdna Station*, on which Gordon was raised. 'I wear my hat for protection, I suppose, and tradition. I use it for nearly everything: distracting a bull from butting, putting it over the snake's head so I can pick him up, everything. He's a dull old life without a good hat'.

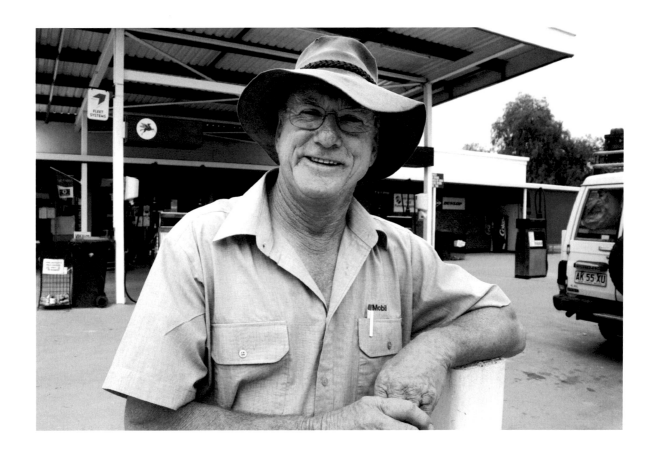

74

JOHN TEAGUE
Hawker, South Australia

Every town needs a good Samaritan, and John Teague is just that in Hawker. He is owner of the Mobil station, which he inherited from his father, Fred Teague, a famed outback mailman who delivered mail to remote outstations in the 1930s, 1940s and 1950s. As the local Royal Automobile Association on-call mechanic, John is known to help anyone who stops by. 'This hat looks pretty bloody rough. It's hanging down a bit—drooped. My wife keeps telling me that I need a new one. Gotta wear a hat out here. When you are doing a job on the road you need a hat. I even wear it under cars when I am working; it keeps the grease off me'.

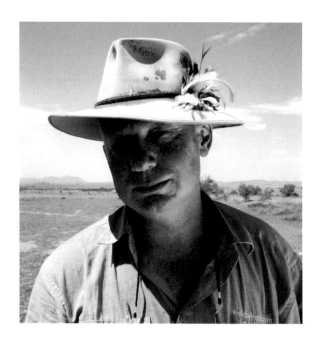

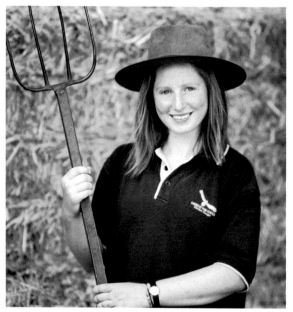

75

SARAH VOUMARD
Rawnsley Park Station, South Australia

Jillaroo Sarah Voumard is a horse handler and guide at *Rawnsley Park Station*, in the Flinders Ranges. She took a year off her studies on environmental policy and management to spend time working on farms. 'I got this Akubra Cattleman this time last year 'cause I worked as a jillaroo at *Mulgating Station*, near Coober Pedy. It was good, but you certainly learned about your limitations. I wear my hat all the time, especially when I take tourists for a ride. I haven't got bored doing the trail rides here at all. The country is so beautiful, and if the tourists can ride we can go for a canter'.

PAUL KEEN
Quorn, South Australia

The man with the feathers in his hat is Paul Keen, a tour guide and photographer from Quorn. His company, Wallaby Tracks, runs personalised tours through the Flinders Ranges. 'I wear a hat because I hate wearing sunscreen. I collect feathers to put on the band—it gives a standard Cattleman a bit of character. I have feathers from a wedge-tail eagle, red-tail black cockatoo, yellow-tail black cockatoo, emu and a few others'.

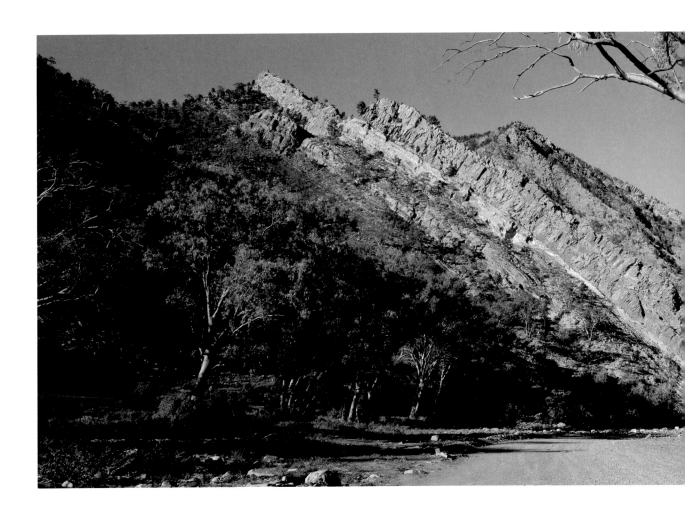

76

BRACHINA GORGE

Brachina Gorge is one of the Flinders Ranges National Park's most popular and spectacular tourist attractions. The 20-kilometre-long gorge is an important refuge for the yellow-footed rock wallaby as well as many species of birds and reptiles. The gorge showcases 130 million years of the earth's geological history. Because of its dramatic rock faces, the gorge is a favourite location for painters and photographers.

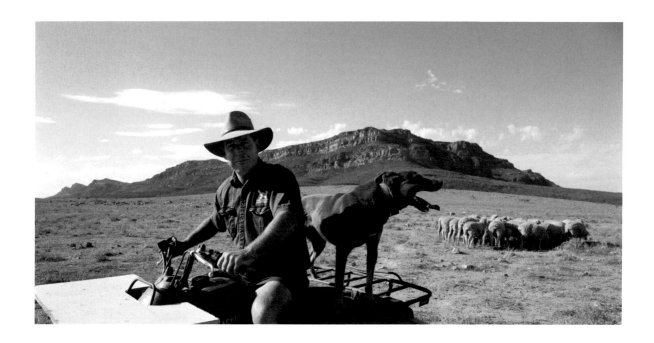

TONY SMITH
Rawnsley Park Station, South Australia

Rawnsley Park Station owner Tony Smith wears an Akubra Cattleman. He is a fourth-generation farmer in the Flinders Ranges. 'The great-grandparents came here in the 1880s, and Dad got this place in 1953'. *Rawnsley Park* borders Wilpena Pound, and Tony has developed a successful tourism operation as well as maintaining a working sheep station. 'When I am out in the sun, I have to wear something— I have no hair. In the last 20 years, I have always worn a hat. I like my hat. It becomes a part of who you are. You're comfortable with it on and uncomfortable without it. My kids call me a bit of a hillbilly'. *Rawnsley Park* carries about 600 sheep, and Tony's dog is called Kev. 'Kev and I, we can do anything'.

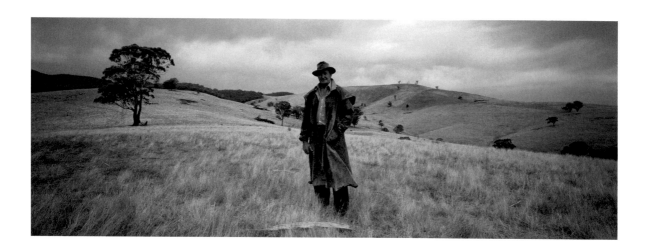

JIM COMMINS
Ensay, Victoria

Jim Commins lived near Ensay, on the eastern slopes of the Dividing Range in northern Victoria. This is the high country—the home of the mountain cattlemen and 'The Man From Snowy River'. Jim was president of the Mountain Cattlemen's Association of Victoria for eight years. He is seen here wearing a Squatter hat to 'stop my head getting sunburnt and the raindrops running down the back of my neck. It's not comfortable 'til you can pick up hot horseshoes with it or radiator caps nowadays'. His wife, Norma, called his hat a 'cowpat'.

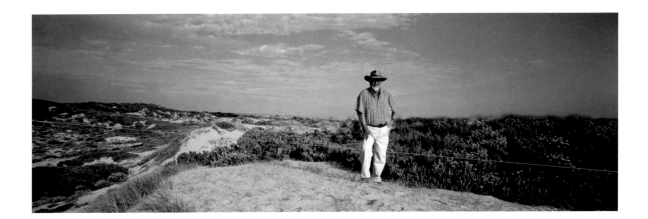

BILL KING
Mornington Peninsula, Victoria

Retired outback tourism pioneer Bill King now
lives on the Mornington Peninsula and has had a
few hats over the years. He wears a hat when it is
really hot 'to get a bit of shade. It's good on a wet
day—stops the water running down my neck. I
bought this Sombrero in 1967 at Blackall while
taking a group of school children to Ayers Rock
via west Queensland. I wear it for a western
night at the golf club so it gets an airing now and
again. It doesn't get worn as much these days.
Now it's just a treasured possession'.

ACKNOWLEDGMENTS

I would like to thank the following people, who have helped make this book possible:

Gail Liston

Kirsty Melville

Deborah McQuoid

Bonnie Fay

David Shaw

I particularly would like to thank all the people I met on my travels who offered me friendship, hospitality and anecdotes about why they wear their Akubras.